Treasures
from the collection at the Fashion Museum, Bath

Bath is a city of glories and treasures. From the Roman Baths in the city centre to the Georgian crescents scattered across the steep hillsides, people have been visiting the city for centuries to enjoy the ambience and to marvel at the treasures on display.

On the northern slopes of the city, in a quiet residential street, which is yet only a few minutes walk away from the Circus and the Royal Crescent, lies one of Bath's hidden gems. This is the collection at the Fashion Museum, located in the grand Assembly Rooms. For those in the know, this is a world-class museum collection of contemporary and historical dress that is second to none. For those who have yet to learn about the riches of the collection, then the Fashion Museum is itself a treasure waiting to be discovered.

Fashion is one of those perplexing subjects that to a greater or lesser extent affect us all, even those people who profess not to be touched or troubled by it. The way that our clothes are cut and put together; the colour, pattern and decoration of garments; and the fabrics from which they are made – all are affected by up-to-the-minute thinking and practice in the fashion industry.

This seems a very modern phenomenon; and yet, surely, this has always been the case, and fashion truly is the backdrop to life, in the past as well as the present. The way to discover whether this might be so is to explore the museum's collection of fashionable dress from the 17th century to the present day.

A museum is a collection of precious objects, and this souvenir book showcases treasures in the Fashion Museum collection. From the beautiful embroidered pieces of the 17th century to the show-stopping ensembles from the world's most famous fashion designers at the beginning of the 21st century, these pieces give visitors the opportunity to discover more about fashion, and to marvel at the beauty of the design and the exquisite craftsmanship of the work.

The Fashion Museum came to Bath as the Museum of Costume in 1963, and was the brainchild of Doris Langley Moore, an inspired collector, writer, scholar and costume designer who was passionate about fashions of the past. It is her vision that continues to inspire the work at the Fashion Museum today as we continue to add fashionable objects to the collection and to find new ways of presenting our treasures to the many thousands of people from around the world who visit the museum each year.

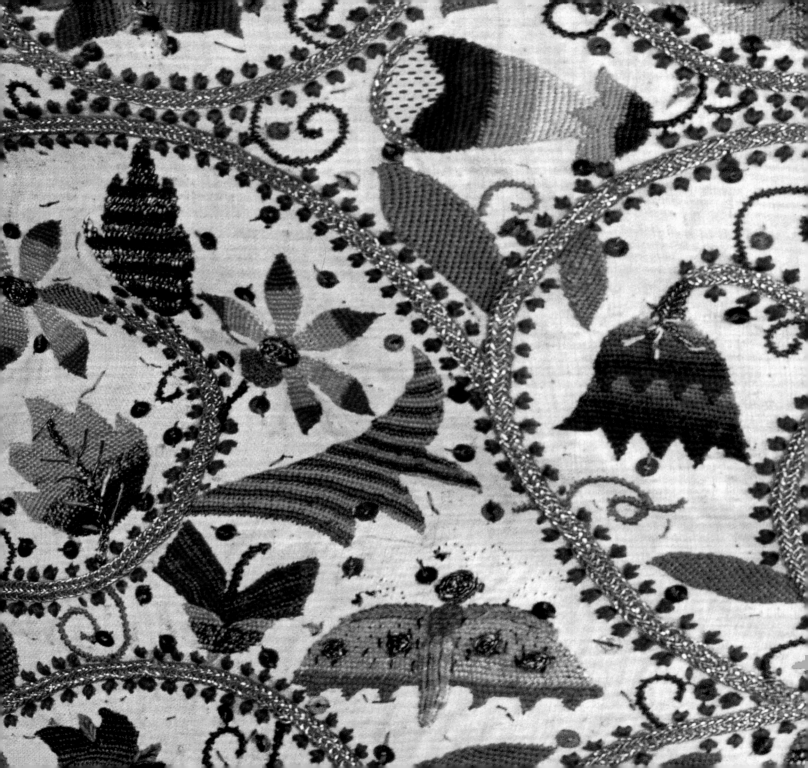

Before the 18th Century
Decorative embroidery and supple linen

Fashionable dress older than the early 18th century tends not to survive in any quantity in costume and fashion museums. However, the collection at the Fashion Museum in Bath includes several treasured objects that date from much further back in history. There are embroidered garments from the end of the 16th century when Elizabeth I was queen, as well as other embroidered fashion accessories from the 17th century when James I and Charles II were kings of England.

All of these items of fashionable dress were made by hand; they date from a time before garment and textile production was mechanised. The cloth from which the clothes were made was woven on looms operated by hand. The pieces of fabric were embroidered and then cut and sewn together by hand to make up the finished garment. Although the construction of clothes was quite simple, with none of the elaborate shaped pattern pieces that developed in the 19th century, textile and clothing production was still a time-consuming, and therefore costly, business. Consequently highly decorated garments such as embroidered jackets and woven dresses were precious commodities, which were treasured and used to good effect.

The earliest mechanisation in the textile industry was the knitting frame, used for garments like stockings and caps, which is reputed to have been invented by the Reverend Lee in the East Midlands in the 1580s. It was to be another 200 years before cloth was woven on mechanised rather than on hand-operated looms.

The production of textiles was nevertheless a professional business in the 16th and 17th centuries. There were workshops and organisations for trades like embroidery and weaving, which had their origins in the medieval guild system. A guild was a grouping together of workers in one particular trade, which set and maintained professional standards and controlled the sale of its goods. One of the earliest records of a guild operating in England is the royal charter granted to the Guild of Weavers in 1155.

As well as being renowned for the beauty and quality of its embroidery, England was well known for producing fine woollen cloth. However, many of the other textiles used in fashionable dress before the 18th century were not produced in Britain, but in Europe. Various different types and weaves of silk – satins, brocades and velvets – were woven in Italy and France. Linen was imported from the Netherlands and from Germany, and lace came from the Low Countries and from France.

These fine textiles were sold at drapers, linen and silk merchants and milliners. Although there was a wide range of these shops in other towns in England, London was the leading shopping city, and also the centre of the international trade in luxury goods. As such it was the place where those who wished to be fashionable went to buy fabrics for their clothes and all the other accessories to fashionable dress such as trimmings, collars, cravats, ruffles and gloves.

There was a thriving and organised trade too in second-hand clothes and fabric. Clothes represented wealth; they were regularly listed in wills and inventories and always with a note of their market value. Second-hand clothes therefore were not just hand-me-downs, but real economic assets.

1580s Man's embroidered shirt

This embroidered linen shirt is one of the oldest treasures in the collection at the Fashion Museum. It dates from the final years of Queen Elizabeth I's reign. The design of insects and flowers was taken from a contemporary embroidery pattern book, and the lines and dots showing the outline of the image were drawn on to the fabric of the garment. Professional embroiderers – who were generally men in the 16th century – then stitched the design by hand using dyed linen or silk threads. The decorative embroidery on the shirt would have shown through vertical slits in the short jacket-like garment, known as a 'doublet', that was worn over the top.

Lent by the Vaughan Family Trust

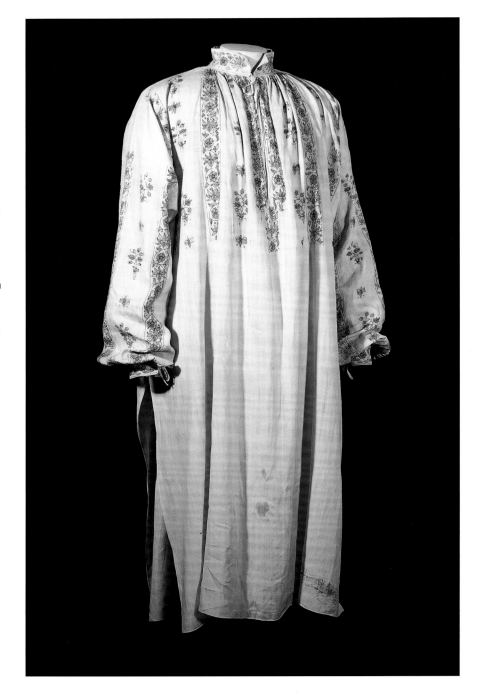

1620s James I's hunting gloves

In 1603 James VI of Scotland became James I of England, unifying the Scottish and English kingdoms. These are said to be his hunting gloves. It seems unlikely that the king wore these beautifully made and lavishly decorated gloves when hunting animals. It is more likely that they were ceremonial, and were perhaps given as a gift to the monarch. They are made of doeskin leather that has been stained brown. The long triangular shape means that they are described as 'gauntlet' gloves; the gauntlets are decorated with applied triangles of red silk satin embroidered in silver metal threads. The loops of red ribbon at the edge of the gauntlet kept the two sides together when they were worn.

Lent by the Glove Collections Trust; conservation supported by the Worshipful Company of Saddlers

1620s Gauntlet gloves

This pair of doeskin gauntlet gloves, with an ornate and intricate embroidered design of winged beasts and camels, is one of the treasures of the Spence collection of historic gloves. Many people with different skills would have been involved in making a pair of gloves of this quality. A leather dresser would turn the animal skin into workable leather; next a glove maker would cut out the gloves from the prepared leather; embroiderers would work the design on to the glove panels; and finally, women outworkers stitched the pattern pieces up into finished gloves.

Lent by the Glove Collections Trust; conservation supported by John Gardner, Past Master of the Worshipful Company of Glovers of London

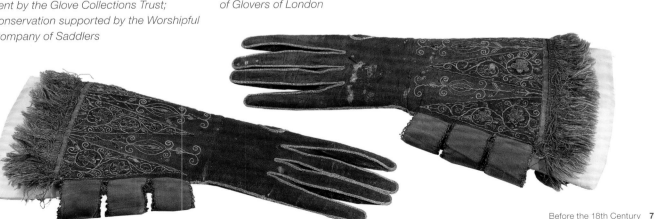

1600s Baby's cap

It is possible that this fine cotton cap from the early 17th century was made for a child who wore swaddling clothes. Until the 18th century it was the usual practice in England to wrap, or 'swaddle', newborn babies in lengths of cotton fabric, which could at times be over 3 metres in length. People thought that tight binding would protect the baby from falls and accidents, as well as encouraging the growth of straight arms and legs. The delicate and intricate needlework of the smocking embroidery on the back of this cap suggests that this was the outer cap; the baby would wear a second plainer cotton cap beneath it.

Gift of Miss Minet

1620s Jacket

This colourful embroidered linen jacket was just one of many garments that went to make up a fashionable look; it was not a complete ensemble in its own right. The 17th-century woman who originally owned this jacket might have worn it beneath an over-gown, so that the decorative embroidery would be only partially visible. This style of embroidery design, with its distinctive pattern of bell-like flowers, striped leaves and butterflies enclosed in large spiral compartments, was also used on hangings in the early 17th century.

Lent by Mrs Bateman and Mr Porter

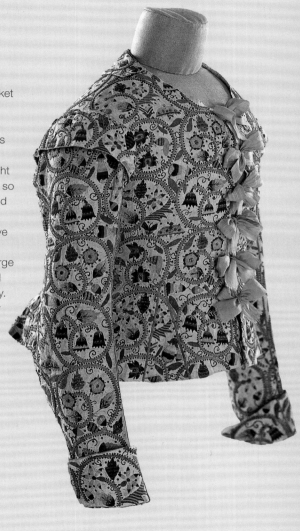

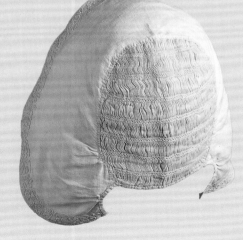

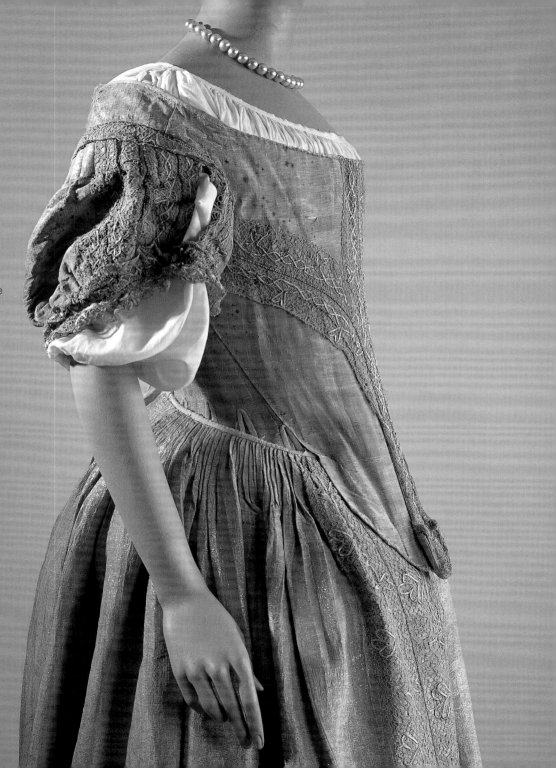

1660s Court dress

This is the oldest dress, and one of the rarest pieces, in the collection at the Fashion Museum. Very few complete dresses from the 17th century survive. It is a court dress and is known as the Silver-tissue Dress because it is made of a fabric where the warp is silk and the weft is silver metal thread. The dress is decorated with applied parchment lace, a silk bobbin lace enclosing strips of parchment. All of these materials were costly. In fact at this date it was not unusual for the lace used to decorate a dress to be more expensive than the fabric from which the dress was made. The Silver-tissue Dress was therefore a dress to be worn at grand occasions, such as attendance at a royal court, in the presence of King Charles II.
Lent by the Vaughan Family Trust

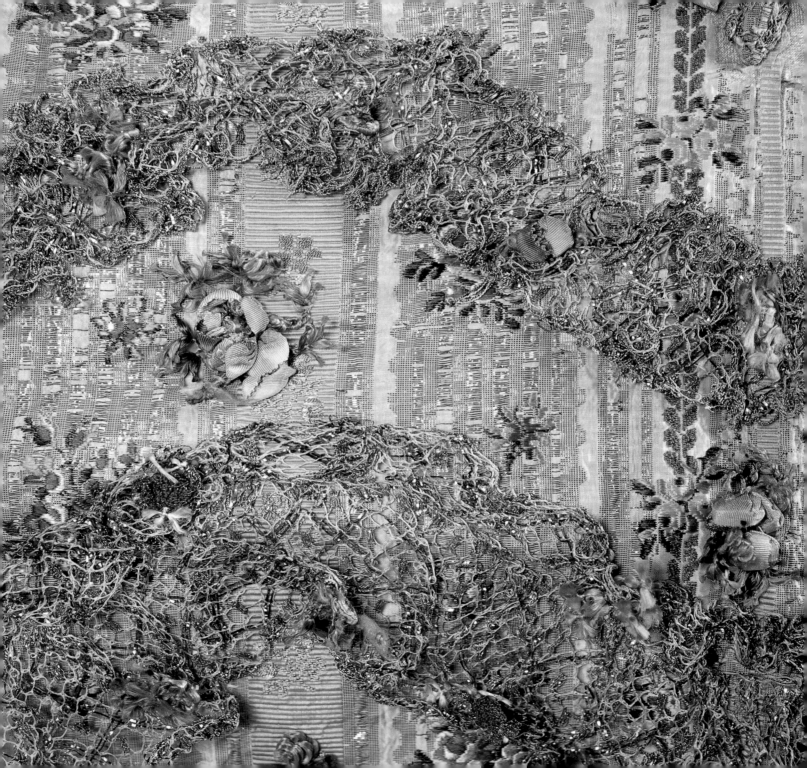

18th Century
Glittering silks and smoothly napped wools

Fashion was regarded as one of the decorative arts in the 18th century, particularly in France, where 'la mode' was considered to be an essential part of good taste and civilized living. The kings of France, such as Louis XIV at the Palace of Versailles, cultivated spectacular and glittering courts where the most splendid and up-to-the-minute dress was required wear. At the beginning of the 18th century, largely because of this demand from the royal courts, a fledgling fashion industry already existed in France. The finest silks in Europe were produced in Lyon, and the idea of a regular seasonal change of style in dress was well established.

In the 18th century other countries in Europe looked to France to set the style for fashionable clothing. Although during the 18th century and the following 300 years other countries had significant fashion industries and made important contributions to global fashion, by and large France remained the centre of fashion and fashionable dress.

Britain's strength in fashion in the 18th century was in woollen clothes – tailored coats of the finest 'home-grown' cloth, often produced in the West Country. This mirrored British society at the time, where power was vested in the landed aristocracy and their country estates, rather than in the Hanoverian royal courts. Practical clothes were needed by those who held sway. Perhaps this is where the characteristic British association between power and less formal clothing originated.

In the 18th century a man would wear a coat, a pair of breeches over knitted cotton or silk stockings, a linen shirt and a waistcoat. It was usual for men to wear a wig, with their heads generally closely shaven.

Throughout the century the basic style of a woman's dress remained the same, although there were variations. The main garment – variously referred to as a 'gown', a 'robe' or a 'dress' – was put on rather like a coat today. It was worn over a petticoat, the front of which was meant to be seen. This could be made either from the same fabric as the main garment or from a plain coloured silk, sometimes quilted in an elaborate design. A flat, often triangular-shaped garment called a 'stomacher' was worn at the front of the bodice. The stomacher was generally pinned in place.

The last 20 years or so of the 18th century saw a change of mood throughout society. There was both political and social change, with movements culminating in the independence of the American colonies from Britain in 1776, and the French Revolution in 1789. In Britain too there was technological and economic change with the increasing mechanisation of textile production, one example being the invention of the flying shuttle by John Kay in 1733. All this change had a direct or indirect effect on the development of fashionable dress. The taste for rich ornate clothes was replaced with a liking for simpler styles; and textiles could be produced more efficiently. A new fashion fabric came on the market: cotton imported from the East meant that softer styles using this easy to drape fabric became more popular.

1715 Man's nightgown

A nightgown, sometimes known as a 'banyan' or a 'dressing gown', was an important garment for men in the 18th century. Worn at home when receiving guests, it was a garment of informal attire generally termed 'undress'. Nightgowns were frequently worn with a close-fitting cap to keep the man's shaved head warm, as he would not wear a wig at home. This nightgown is made of silk damask, a weave in which the same thread is used for the pattern and background meaning that the fabric is all one colour.
Acquired with the assistance of The Art Fund and the V&A/Purchase Grant Fund

1720s Man's embroidered coat

This coat is of the finest quality wool cloth, and was undoubtedly made by the most skilled professional tailors and embroiderers of the day. It is associated with Scottish nobleman Sir Thomas Kirkpatrick, 3rd Baronet of Closeburn, who was born in 1704 and succeeded to his title on his father's death in 1720. The coat would have been worn on very formal occasions or at court. It is made of closely napped West Country broadcloth, considered to be the very best woollen cloth in the early 18th century. Broadcloth was, as the name suggests, particularly wide cloth: it measured 60 inches. Napping was the removal of the raised pile of the woven wool with special napping shears.
Acquired with the assistance of The Art Fund and the V&A/Purchase Grant Fund

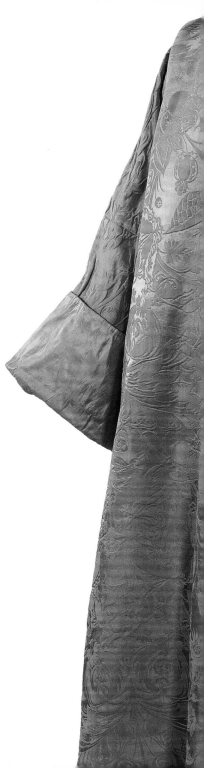

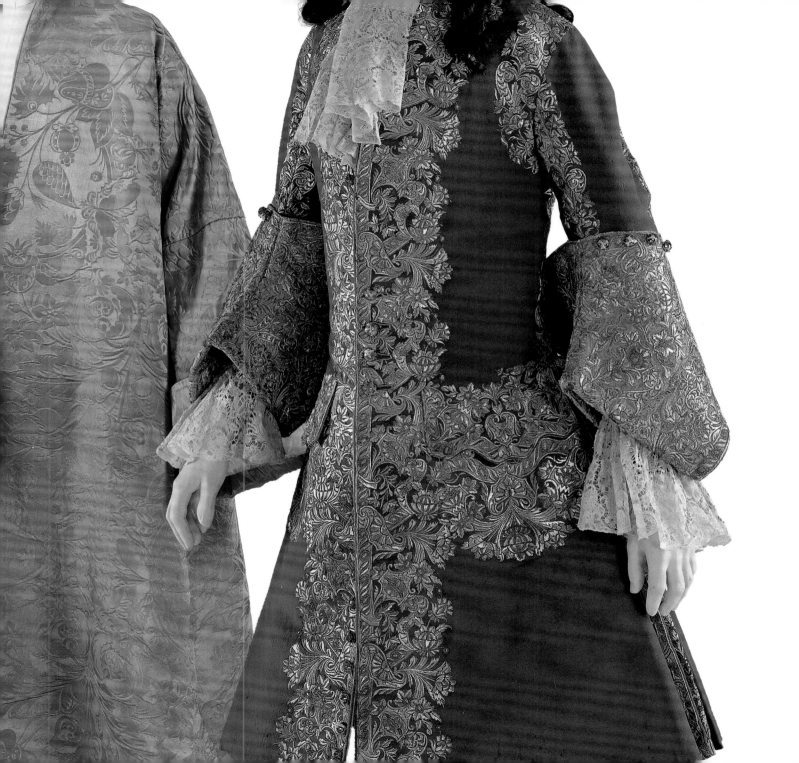

1750s Sack
back dress

A sack back was a dress with broad pleats
falling from the shoulders, at the back.
It was fashionable throughout much of the
18th century, but for different occasions.
In the early 1700s it was a loose informal
garment; it became a fashionable day
dress around the 1720s; and by the 1760s
the style was worn only at court. This dark
pink sack back dress was probably quite
costly as the woven silk from which it is
made incorporates silver metal thread and
silver metal strip, which was flatter. It
was therefore a dress for the most splendid
occasions, and would have glittered in
the candlelight.
Lent by Philip Smith

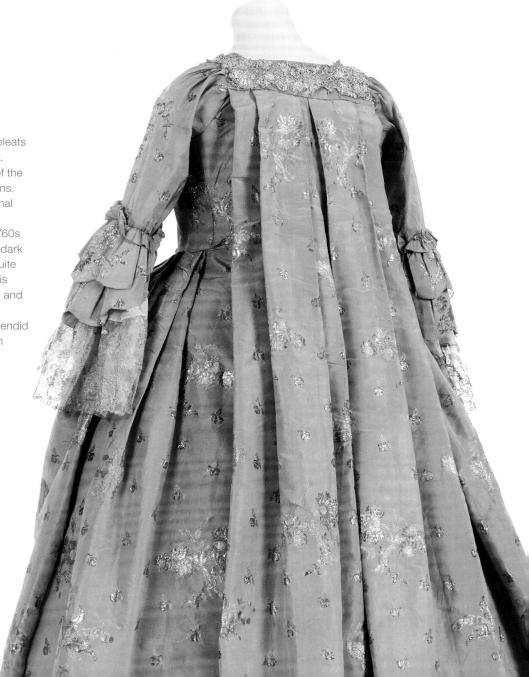

1760s Sack back dress

Dresses like the sack back style, where the edges of the bodice did not meet, and where the petticoat was clearly visible, were also known as 'open robes' in the 18th century. It was a style that was fashionable throughout most of the century. This dress is made of blue 'brocaded silk'; this term referred to cloth in which the coloured weft threads were only used for the motif rather than being carried across the width of the fabric. This method of weaving saved money as it used less silk thread. The distinctive pleats on the back of a sack back dress are sometimes called 'Watteau pleats' because the 18th-century French artist Jean-Antoine Watteau illustrated the style in his paintings.
Lent by Mrs Morris

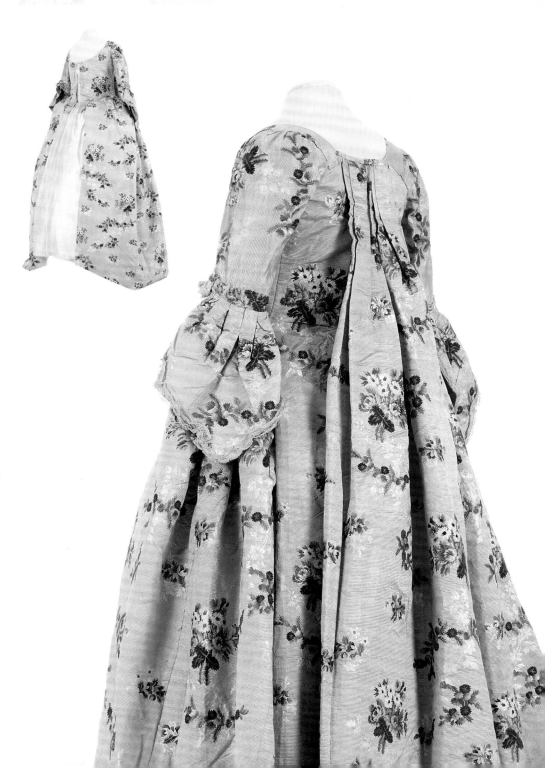

1760s Court dress

In the 18th century it was customary
for the leading members of society
to attend court occasions and to pay
their respects to the monarch. The
most formal and splendid clothes were
demanded for these functions. This
court dress of French silk, brocaded
with gold and coloured threads, might
have been worn at either the English
court of George III, or perhaps at the
French court of Louis XV. Very wide
skirts of this rectangular shape were a
passing fashion of the 1740s but were
retained for court wear for a long time
after. The skirt was supported by
a stiffened under-skirt, held out
by lengths of cane – rather like
baskets worn over each hip.
*Gift of Viscountess Lee
of Fareham*

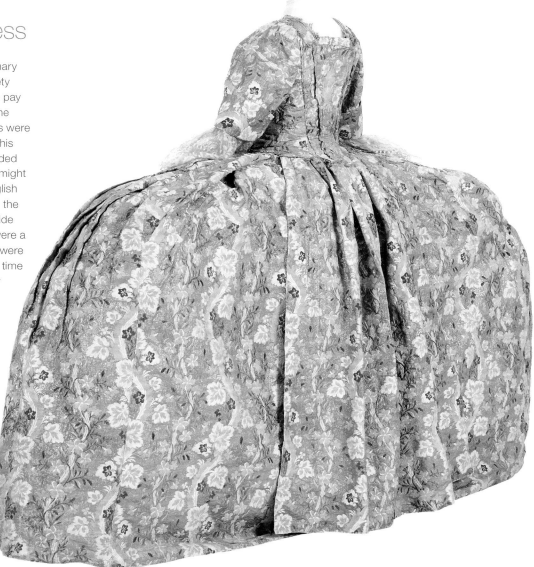

1760s Fashion doll's dress

The original fashion doll has not survived. But its dress has, and is a perfect replica in miniature of the style of dress worn at the English court around 1770, in the reign of King George III. The dress is in three parts – boned bodice, petticoat and train – and is made from silk, which was probably woven in France around 1765. It was made by a 'mantua maker' – the 18th-century term for a person who made women's dresses and loose fitting outer garments. It was not yet common practice to publish fashion journals giving information about new styles; instead mantua makers would show fashion dolls dressed in miniature fashionable ensembles, such as this, to their wealthy clients.

Acquired with the assistance of The Art Fund and the V&A/Purchase Grant Fund

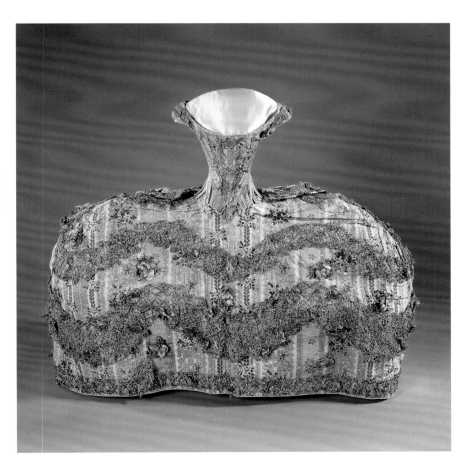

1780s Pair of stays

In the 18th century women of all social classes wore a corset (known as a 'pair of stays') over the top of a linen shift. Stays were made of linen or cotton and stiffened by numerous strips of whale-bone threaded through narrow stitched channels that ran the length of the garment. A pair of stays had shoulder straps and was laced up at the back. Inserted at the centre front was a single panel, usually of wood but sometimes bone or ivory, known as a busk.

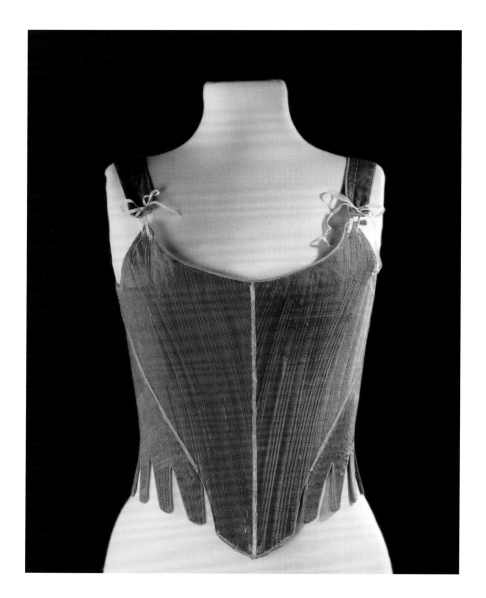

1790s Printed cotton dress

Fashionable dresses were generally made of silk until the late 18th century when linens and printed cottons became the preferred fashion fabrics. Originally imported from the East, by this date they were produced in Britain. The patterns were printed using block prints or the newer engraved copper plates, which had been developed in the mid 18th century. It was easier to achieve fine lines using engraved plates; and this explains the naturalistic tendrils and fronds that were all the rage in the designs of fashion fabrics at this date. Billowing neck handkerchiefs, which were generally made of white cotton, and often embroidered using white cotton thread, were also fashionable at this date.

Gift of Miss A and Miss M Birch

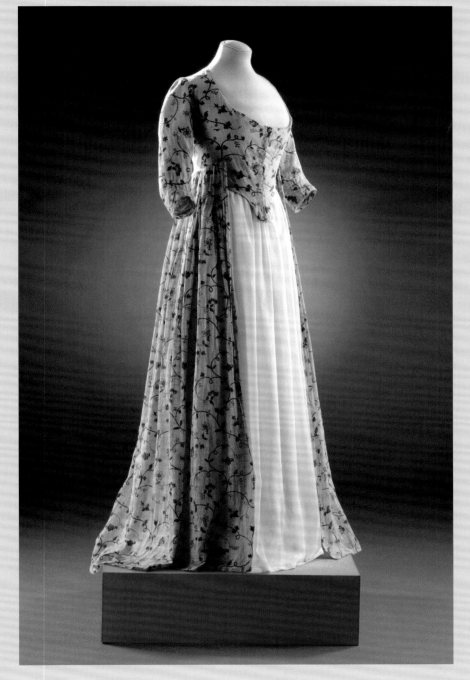

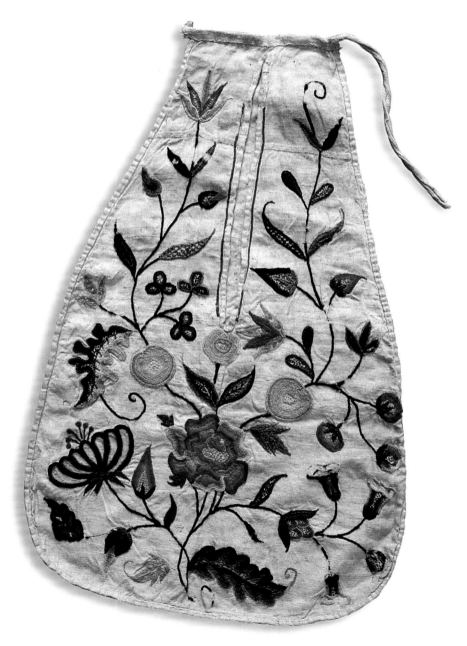

1700s Pocket

This linen pocket, which is embroidered in different coloured wools in a design of flowers and leaves, is a tie-on garment. It dates from about the mid 18th century. It was worn on tapes around the waist, and is probably similar in style to the pocket that Lucy Locket lost in the well-known English nursery rhyme: 'Lucy Locket lost her pocket, Kitty Fisher found it; Not a penny was there in it, Only ribbon round it'. It was usual for women to wear tie-on pockets, either singly or in pairs, either over or under their gowns and petticoats, before the introduction of bags and reticules in the late 18th and early 19th centuries.
Gift of Mrs Lèche

1720s Silk shoe

Women's shoes in the 18th century were often made of the same silk as their dresses. This shoe from around the 1720s is made of green silk damask and is decorated with a broad band of golden metal thread braid. It was common practice to transfer the woven braid to a different pair of shoes, if the old pair wore out. Shoes fastened with ribbons and ties, or with a separate metal buckle, often decorated with paste or glass jewels.

1790s Silk shoe

By the end of the 18th century, the fashion was for women to wear low-heeled shoes that were almost flat. The style perfectly complemented the slender pared down silhouette that was also fashionable. These woven cream silk shoes, with a sharp pointed toe, have a slightly ruched ribbon around the top – very different from the ornate braids and buckles used on women's shoes earlier in the 18th century. They also have a maker's label (with an address in South Molton Street in London) on the inside, and are among the earliest labelled fashion garments in the collection at the Fashion Museum.
Gift of Philip Hall

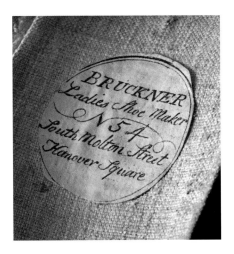

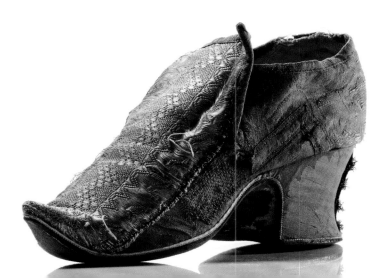

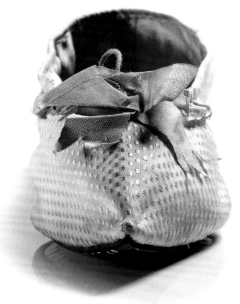

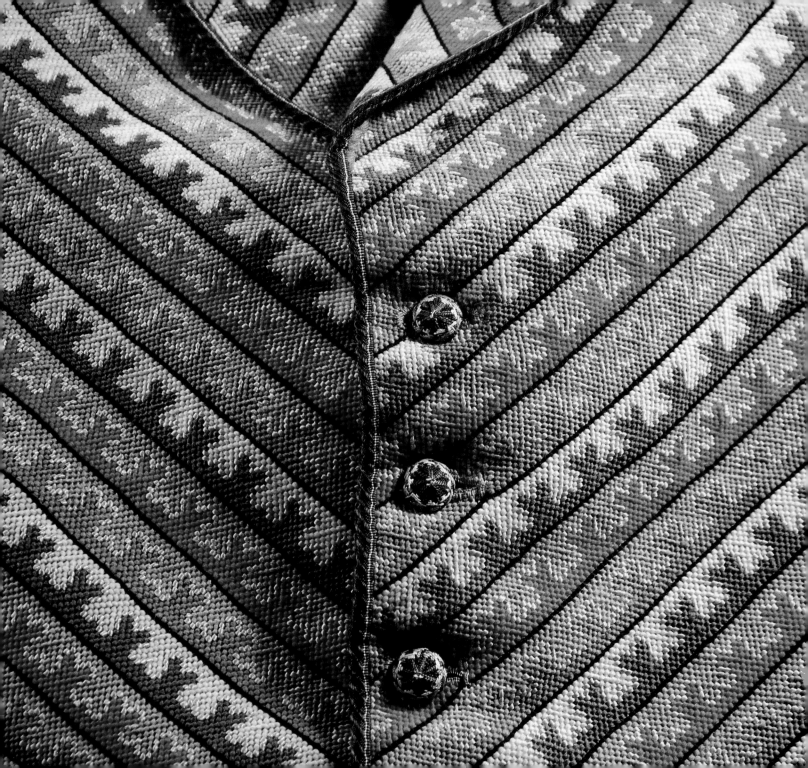

19th Century
Mechanisation and rapid change

The 19th century was a period of expansion in trade and industry resulting in increased prosperity, particularly among the new middle classes. Our view of the 19th century is dominated by the Victorian age, the years from 1837 to 1901 when Queen Victoria was monarch. But earlier in the century, during the reigns of George III, George IV and William IV, there were developments in textile production that had far-reaching effects on fashionable dress. These included the invention of the bobbin net machine in 1808, which mechanised lace-making, and the introduction of the Jacquard loom in the 1830s, which automated weaving.

Advances in technology continued to drive the mechanisation of textile production. Then from 1845 the introduction of the sewing machine brought mechanisation into the area of clothing production. These, and other technological advances (for example, the replacement of whale bone with a flattened coiled spring known as 'watch spring' in the 1890s as the principal material for boning in corsets) meant that fashions could be produced more quickly and therefore more economically. For consumers this meant that garments could be sold more cheaply and that more different styles were produced giving greater choice.

Fashion production had entered a new age, and fashion would never be the same again.

Shopping for fashion underwent a gradual transformation. Rather than buying fabric in a haberdashers, and then paying a dressmaker or a tailor to make up a garment people began to go to the new-style department stores, which were opening in more and more towns and cities throughout Britain. These were big establishments, such as Jolly's in Bath, which opened in Milsom Street in the 1840s. They had a number of different departments, including workrooms where clothes were made to order. Haberdashers, tailors and dressmakers were all under one roof with more goods to order and to buy. Improvements in public transport in major towns and cities meant that it was easier for more people to go to the new department stores.

In contrast to the sedate pace of change in the 18th century all aspects of dress changed radically in the 19th century: clothes for men and women and children, and both outer and under garments.

Take women's underwear; the single shirt-like garment called the 'shift' was gradually replaced by a chemise and pair of drawers, made as two separate legs, with no joining seam at the crotch.

Under-petticoats were worn throughout the century, but by the mid 1850s the heavy multiple layers, sometimes as many as six petticoats, were replaced by a new undergarment, the crinoline frame. This was a cage-like construction made of graduated hoops of flexible steel that held out the ever-widening skirts of a woman's dress. It was much more comfortable to wear, but quite impractical. By the late 1860s it in turn had been replaced by the bustle – a smaller wire frame or a pad made of frills of horsehair worn in the small of the back to hold out the skirt of a dress. By about the late 1870s the bustle too was out of fashion. A tight and slender silhouette was briefly fashionable but replaced by the crinolette, which was, in effect, half a crinoline with the hooped wire structure worn only at the back.

In the early years of the 19th century men wore breeches; but very soon the fashion changed, and by the 1820s it was normal for men to wear trousers, except for court and ceremonial dress. Early on, trousers tended to be made of wool, and sometimes cotton, in lighter colours, but as the century progressed darker shades became the norm.

1800 Evening dress

Fashion at the beginning of the 19th century was inspired by the neo-classical taste, with a vogue for slender column-like dresses that copied the drapery of Greek and Roman statues. It was fashionable to wear white dresses made of lightweight cotton muslin, which draped into beautiful folds. Dresses might be decorated with embroidery in white cotton or silver metal thread. This dress is embroidered with tiny cylinders of white glass sliced through to make decorative beads.
Gift of Barbara Jones

1815 Pelisse

A pelisse was a coat-like garment, often made of soft twilled silk known at the time as 'sarsanet', which was fashionable in the early years of the 19th century. At the beginning of the century styles were shorter, to the hip or the knee, but by about 1810 the pelisse was full length, as with this example in brown sarsanet. Although it could be worn indoors, a pelisse was most often worn as an outside garment with a close-fitting bonnet and low-heeled shoes or boots.
Gift of Susan Nicholls

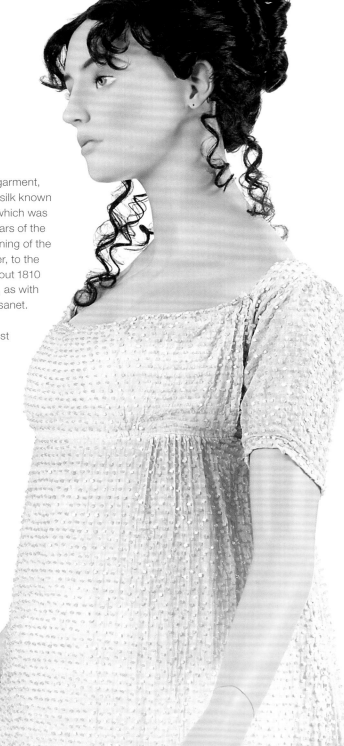

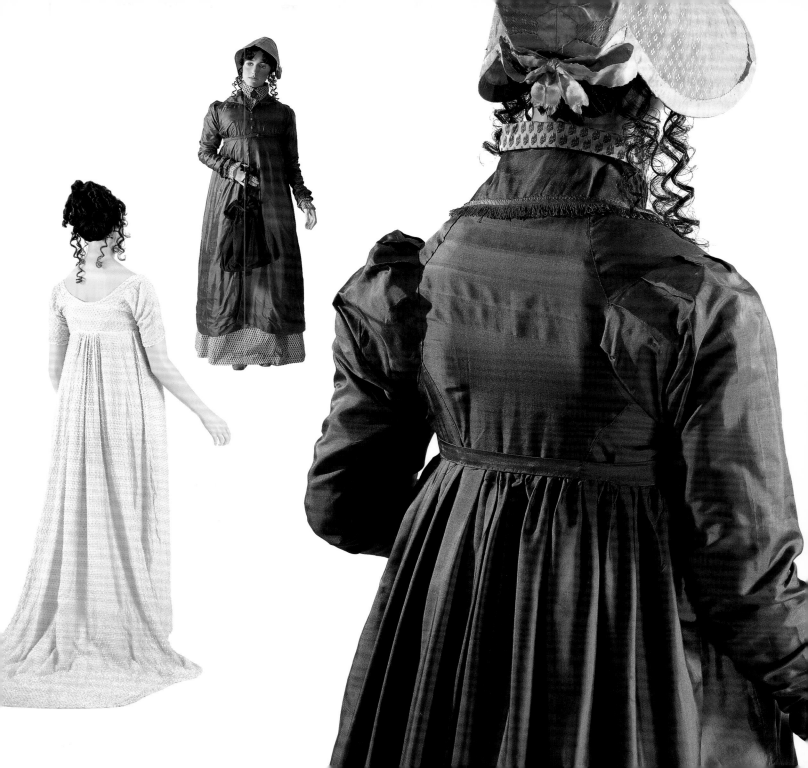

1829 Evening dress

Women's fashions were decorative and pretty in the 1820s and 1830s. The waistline on dresses dropped to its natural level, and skirts became much broader. The close fitting sleeves fashionable in the early years of the 19th century were replaced with giant puffed 'gigot' or 'leg-of-mutton' sleeves, as on this dress. There was a fashion for blonde lace – a densely patterned bobbin lace made of cream silk – at this date, with collars and sometimes complete dresses made of this delicate material. The machine-woven gauze of this dress is similar in appearance to blonde lace.

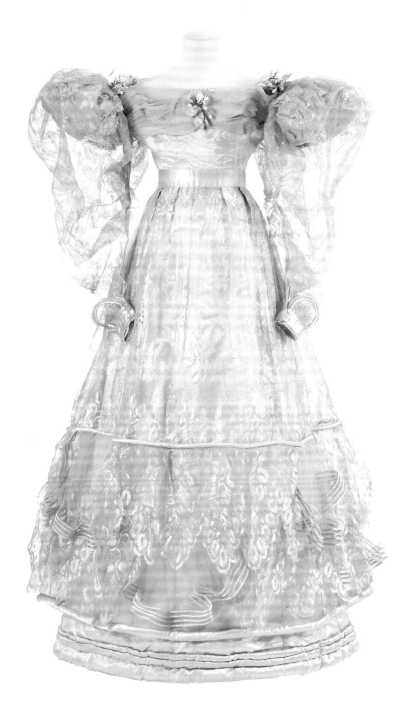

1840s Day dress

There was a new mood in fashion following the accession of the young Queen Victoria in 1837. Ornate romanticism was replaced by a more restrained and quieter taste in dress, with softer colours in plainer fabrics, and less exaggerated shapes and decorative detail. The wool fabric from which this dress is made is roller printed in a design of green leaves and purple and pink flowers. Roller printing was the first form of mechanised fabric printing and was invented at the end of the 18th century.

Gift of Miss Ingleby

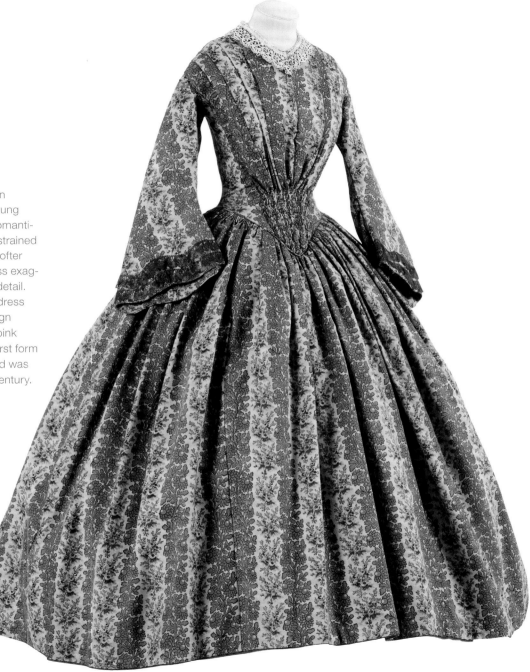

1821 Ceremonial costume

The Prince Regent became King George IV on his father's death in 1820. This costume was worn at the coronation of the new king in 1821 by William, 8th Duke of St Albans. The honorary title of Hereditary Grand Falconer was bestowed upon the dukes of St Albans in 1684 by Charles II. The coronation of George IV was a theatrical pageant, designed by the new king to emphasise the historicism and tradition of the monarchy. The Duke of St Albans walked in the coronation procession with other dignitaries who had official roles in the workings of the monarchy, such as privy councillors and barons, as well as those with more ceremonial roles, such as a herb strewer.

Gift of Lord Wakehurst

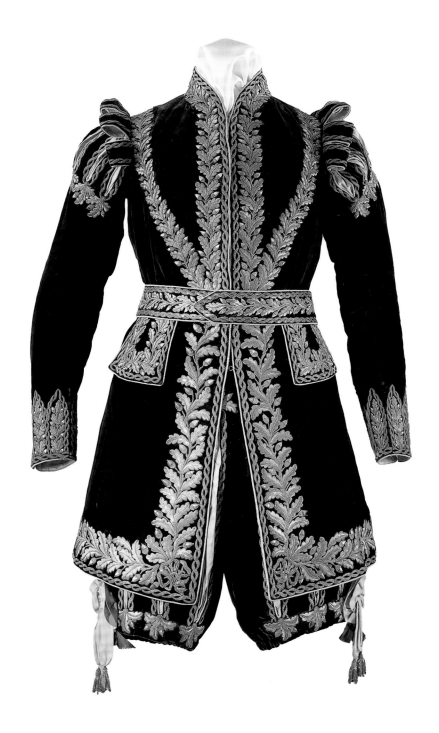

1840s Man's waistcoat

This waistcoat with its diagonal design in bright colours is typical of the fashion in the 1840s for men to wear flamboyant coloured and patterned waistcoats. This style was much remarked on in the contemporary press. The author Charles Dickens, for example, took briliantly coloured and richly embroidered waistcoats on a tour to America in 1842, and he was derided by the press for being 'somewhat in the flash order'. This embroidered canvas waistcoat, with its strong colours and delicately embroidered buttons, is far from garish. All of the embroidery threads were dyed using vegetable dyes. Colourful waistcoats were a relatively short-lived fashion: by the 1850s, a man's coat, waistcoat and trousers were all made of the same darker fabric.

Gift of Mrs Joscelyn-Wilkie

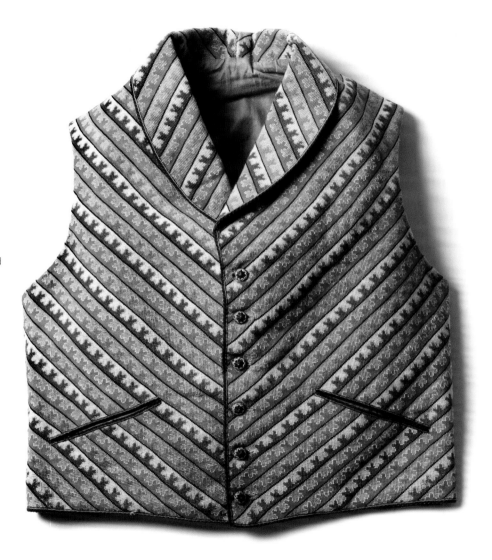

1870s Evening dress

This is an example of the relatively short-lived fashion in the late 1870s for the 'princess' line dress. This was a slender all-in-one style of dress, which fastened either with a long line of buttons or, as in this example, with a line of hooks and eyes. This dress of gold coloured silk satin would have been worn with a bustle – a small wire frame or pad of horsehair frills worn on a tape around the waist – to hold out the drapes and puffs of the two different types and weights of silk.
Gift of Lady Trefgarne

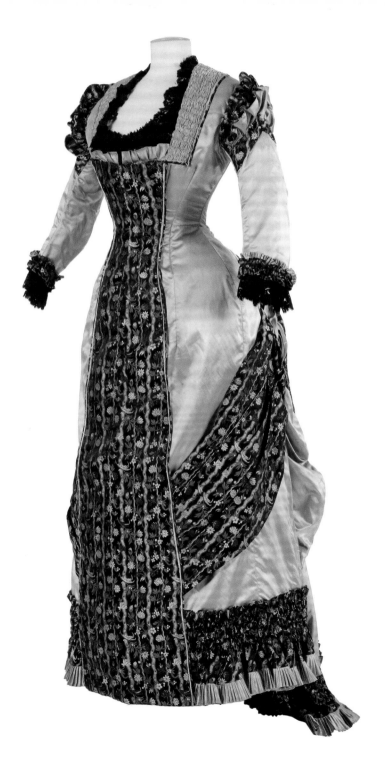

1880 Crinolette

Crinolettes were fashionable from about the early 1880s. They were undergarments made of hoops of wire suspended together with linen tape, which were worn around the waist so as to give a woman's dress the correct fashionable shape. A crinolette was different to the earlier cage crinoline: the structure was at the back rather than all the way round. This crinolette is by the firm of W.S. Thompson. Little is known about the firm and its originator, despite the fact that there are many surviving cage crinolines, bustles and crinolettes by W.S. Thompson in museum collections, as well as advertisements for their products in 19th-century newspapers.
Gift of Helen Gordon-Thompson

1800s Costume jewellery

Ivory jewellery was popular in the 19th century. One of the most common designs for carved ivory brooches was a scene incorporating either a single stag or a stag and deer, as in this delicately worked example from the 1840s. Dieppe in France was a centre for ivory carving, but this brooch was made in Switzerland, which was also known for the quality of its ivory work. By contrast the leaf-shaped brooch from around the 1860s is made of jet, a black fossilised variety of coal, which was found principally in Whitby in Yorkshire. Jet jewellery was so popular, particularly for mourning, that the number of jet workers in Whitby increased from seven in 1850 to over 1500 by 1870. The third brooch is a cameo; cameo jewellery was fashionable throughout the 19th century, and this example from the 1890s is a particularly precious carved and engraved agate cameo.
Gift of Mrs Hull Grundy and Mr Giffard

1880s Evening dress

The fashion in the 1880s was for dresses that looked almost sculptural and were made of richly coloured and textured fabrics such as brocades, velvets and silk satins. This evening dress is a good example with its combination of textured woven silks in peach and blue, the figured brocade and the heavy ribbed silk. The fabric of the skirt is gathered, folded and draped to give a 3-D effect. Evening dresses in the 1880s were cut quite low in the bodice, and were often worn with a choker or necklace. This style of evening dress can be seen in the paintings of artists such as James Tissot.

1890s Queen Victoria's dress

This fine-quality black silk dress, decorated with black embroidered net, was worn by Queen Victoria. There are two narrow panels of mourning crape on the bodice of the dress. It was usual in the 19th century for a widow to wear crape in the early stages of mourning, changing then to black silks and velvets, and finally to lighter colours like white, grey and shades of purple. But Queen Victoria wore deep mourning for her husband Prince Albert, who died of typhoid fever in 1861, for the rest of her life. Queen Victoria herself died at Osborne House on the Isle of Wight in January 1901.

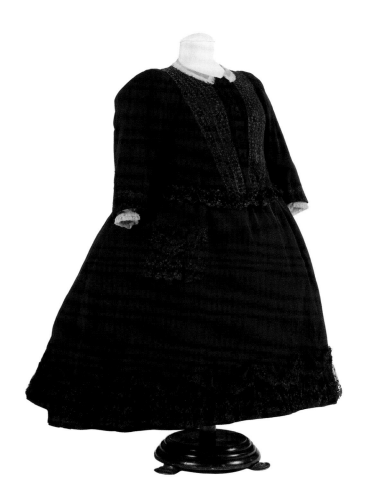

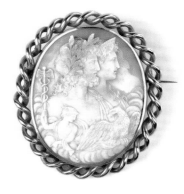

1890s Mary Chamberlain's shoes

Mary was the daughter of William Endicott who was the Secretary of War under President Grover Cleveland of the United States. Mary married Birmingham politician Joseph Chamberlain in 1888, becoming his third wife (and stepmother to his sons, the 20th-century politicians Austen Chamberlain and Neville Chamberlain). Mary had an unerring eye for stylish clothes, and bought much of her wardrobe in Paris, as was usual for American women of her status at the end of the 19th century. A collection of Mary's clothes was given to the Fashion Museum following her death in 1957, including a number of pairs of shoes by Paris designers in bright coloured silk satins. Mary chose the same style of shoe, but in a range of different colours.
Gift of the Executors of the Estate of Mary Carnegie

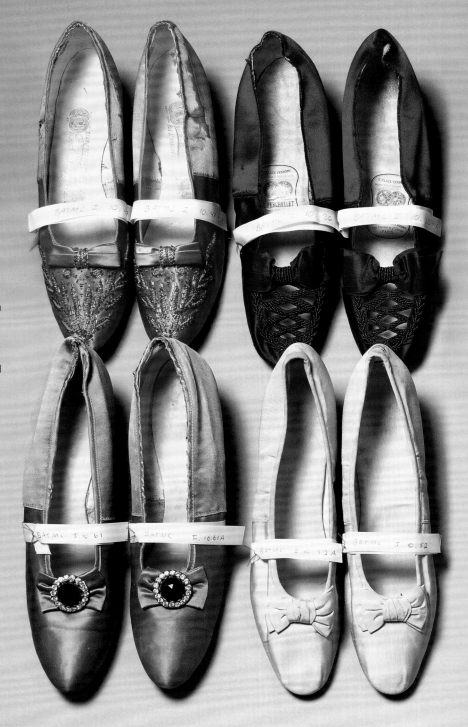

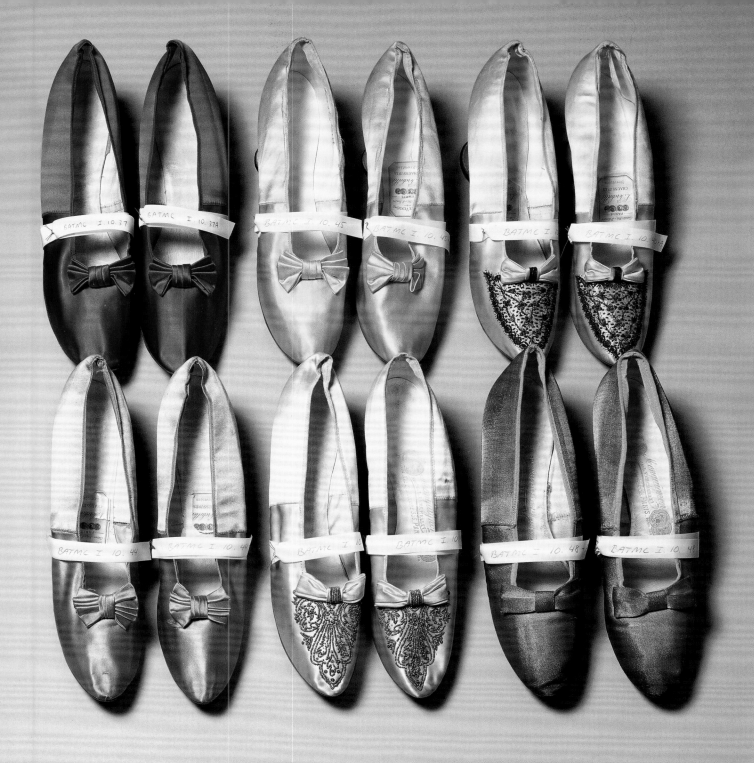

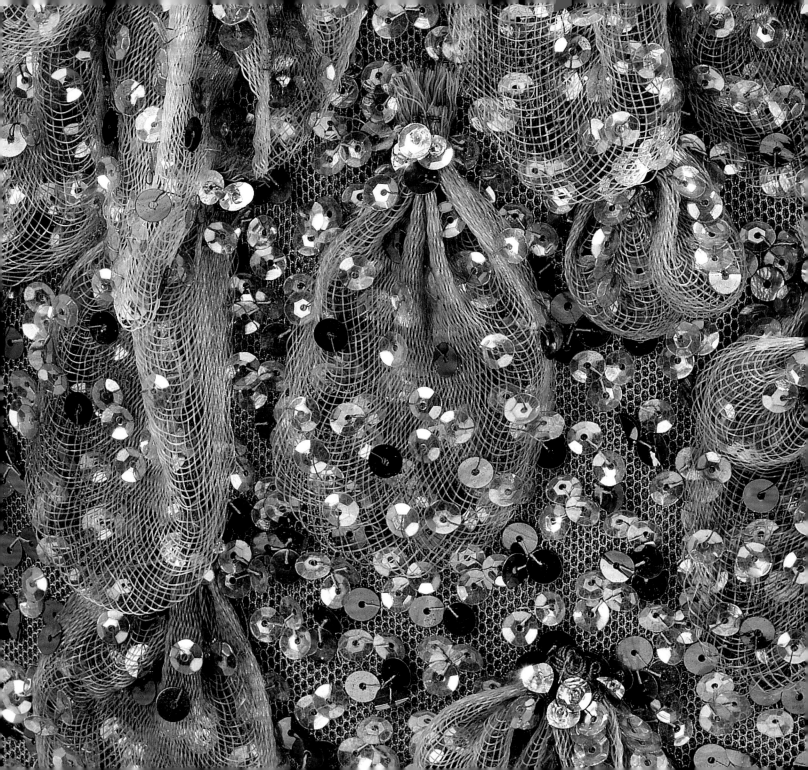

20th Century
Designers, synthetics and ready-to-wear

The types of garments that were considered appropriate for women to wear changed enormously in the 20th century. In 1900 women were tightly corseted and wore long dresses, often made of silk with elaborate decoration, which rustled as they walked. By the year 2000, women could wear trousers and go out to work on building sites if they so chose. Increasingly throughout the 20th century, women in western societies had more choice about how they lived their lives, and how they chose to dress. The 20th century, more than any other century, showed how changes in lifestyle, and increasing opportunities for women, can affect the nature of fashionable clothes.

The way that clothes were made underwent a radical change, and this too had an effect on the variety of styles that were available. The changes in clothing production during the 20th century also led to increasing standardization. In 1900 most clothes were still made to order. Affluent women had their clothes made at a couture house or by a court dressmaker. Women of more slender means went to the dressmaking departments of large shops, or to dressmakers, or made their own clothes at home. But advances in clothing production meant that in the 1920s and 1930s it became more usual for clothes to be made to pre-determined

sizes. At this date, these off-the-peg clothes still had the reputation of being inferior to those that were made to measure. Eventually, continuing technological advancements and improvements in sizing meant that well-made, well-fitting ready-to-wear clothes, which could be bought at a reasonable price, became the norm.

Synthetic fabrics were used more and more for fashionable clothes. The earliest man-made fibres imitated silks; they were known as 'art silks', although from the mid 1920s 'rayon' was the more usual term. Nylon was produced in the United States in 1938, and thereafter many other synthetics, known by brand names such as Terylene and Orlon, flooded the fashion market. In the latter part of the century there was a backlash against man-made fabrics, and natural fabrics such as cotton, linens and wools were chosen. However, developments in fabric technology meant that new fabrics were still being invented. Often used first in sportswear, they are used extensively in fashion today.

In the world of fashion, the 20th century was the century of the designer. Previously, people who designed and made clothes were regarded as craftsmen rather than artists, and were rarely named or identified. By the end of the 19th century fashion designers such as Worth

and Doucet, both of whom worked in Paris, started to become more well known. From then onwards it became increasingly usual for fashion designers to be named, with Chanel, Schiaparelli and Vionnet (all of whom were women) finding particular fame. It was perhaps only with Christian Dior in the late 1940s and 1950s that the modern idea of a fashion designer as a brand was born, a trend that has continued to this day.

There was a general decrease in the formality of dress throughout the 20th century. Until the late 1950s it was expected that the correct hat or pair of gloves should be teamed with the appropriate suit or dress, depending on whether, for example, you were in the town or the country, and whether this was a lunchtime or an evening function. But by the end of the century this all seemed quaint and old fashioned.

The concept of different types of clothing for different occasions continued with the idea of adapting clothes for day and evening wear, which was addressed through the idea of the 'capsule wardrobe'. This was a concept made famous most notably by American designer Donna Karan in the 1990s, but it was presented as a choice for women, rather than an expectation. There was a wide gulf between prevailing dress codes at the beginning and at the end of the 20th century.

1903 Lady Curzon's evening dress

Lord Curzon was Viceroy of India from 1899 to 1906. His wife Mary Curzon was Vicereine and, as such, was the leader of the social hierarchy of the British Raj in India. She was acutely conscious of her role, and of the part that her clothes played in fulfilling it. She planned her wardrobe carefully each year, and either ordered clothes from Europe or asked her sisters to bring clothes out to her in India when they visited. This yellow silk dress dates from about 1902 after the births of Cynthia and Irene, two of her three children, and was designed by French couturier Jean Phillippe Worth. It was designed to be worn at evening receptions.
Gift of Lady Alexandra Metcalfe and Lady Irene Ravensdale

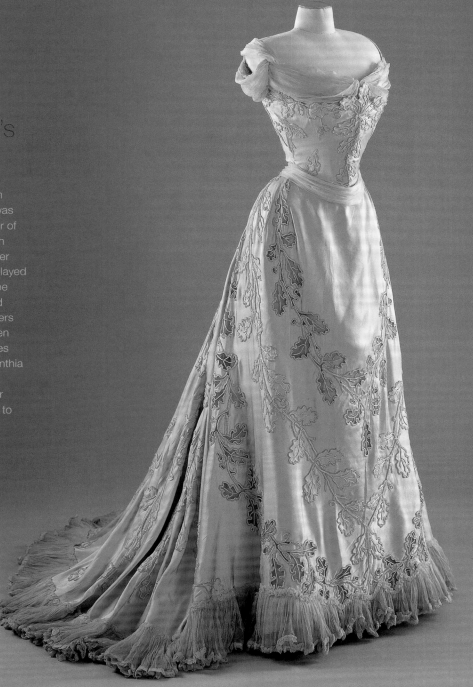

1928 Ottoline Morrell's dress

A patroness of the arts, Lady Ottoline Morrell had an imposing appearance and a flamboyant sense of dress. The Fashion Museum has an important collection of Lady Ottoline's textiles and dress, including this striking yellow ribbed silk dress with an embroidered pattern of flowers in purple silk thread. The style of the dress is from the late 1890s, and the fabric from which it is made is a late 19th-century copy of an 18th-century silk. But the unconventional Lady Ottoline chose to wear the dress in 1928 when she was photographed by society photographer Cecil Beaton for *Vogue* magazine.
Acquired with the assistance of The Art Fund and the V&A/Purchase Grant Fund

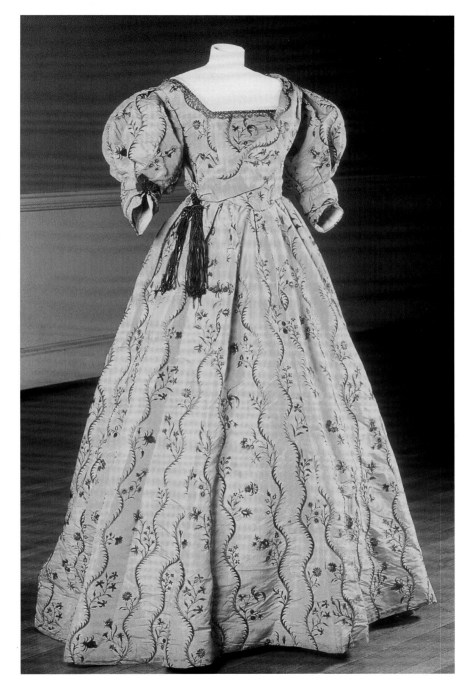

1950s Hat
by Christian Dior

Christian Dior is one of the most famous fashion designers of the 20th century. He trained as an architect and began his fashion career in the 1930s by selling sketches of hats to couturiers. These early beginnings, and his fascination and skill with 3-D design can be seen in the hats that he produced to accompany the fashionable clothes he designed in the 1950s. This velvet toque with a design of overlapping segments was worn by the famous British ballerina Margot Fonteyn, who acquired many of her clothes at the House of Dior in the 1950s.

Gift of Dame Margot Fonteyn

1951 Evening dress by Christian Dior

Christian Dior showed his first collection in February 1947. This was the famous 'New Look' collection, which won immediate fame and notoriety, and has come to be recognised as a key moment in fashion history. Dior continued to generate noteworthy fashion collections over the next ten years before his premature death in 1957. This evening dress, called 'Debussy', is embroidered all over with beads, diamants and raised stiffened gauze. The work would have been done by one of the specialist embroidery ateliers in Paris, such as Brossin de Mere and Lesage, who worked regularly with all the couture houses.

Gift of Dame Margot Fonteyn

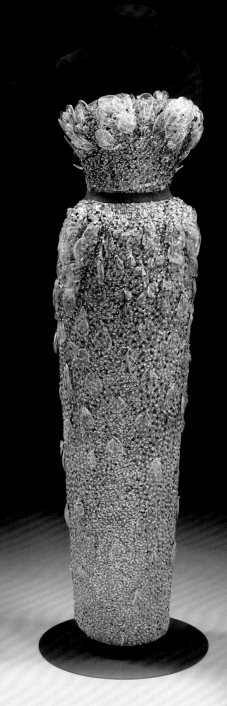

1954 Miss Virginia Lachasse

Miss Virigina Lachasse is a wax fashion doll complete with a miniature couture wardrobe. She was produced by the London couture house of Lachasse in 1954 as part of a scheme to dress a miniature mannequin so as to raise money for the Greater London Fund for the Blind. The doll was modelled on Virginia Woodford, who was house model for Lachasse at the time. Miss Virginia Lachasse has a complete couture wardrobe, with every piece made to scale. Her evening and cocktail dresses were made in the dressmaking workrooms at Lachasse, and her suits and coat in the house's tailoring workrooms. Other leading fashion firms of the early 1950s, such as Aristoc for stockings and Yardley for cosmetics, supplied the rest of the garments and accessories in her wardrobe.
Gift of Peter Lewis Crown

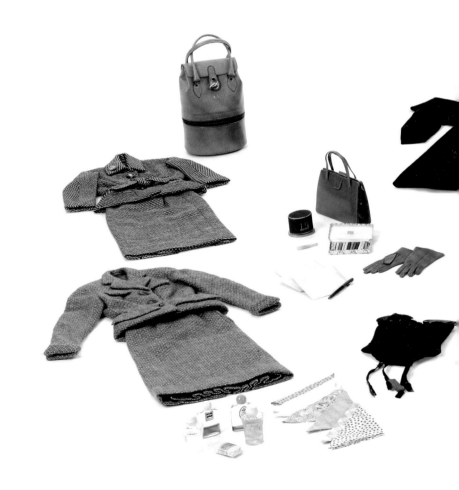

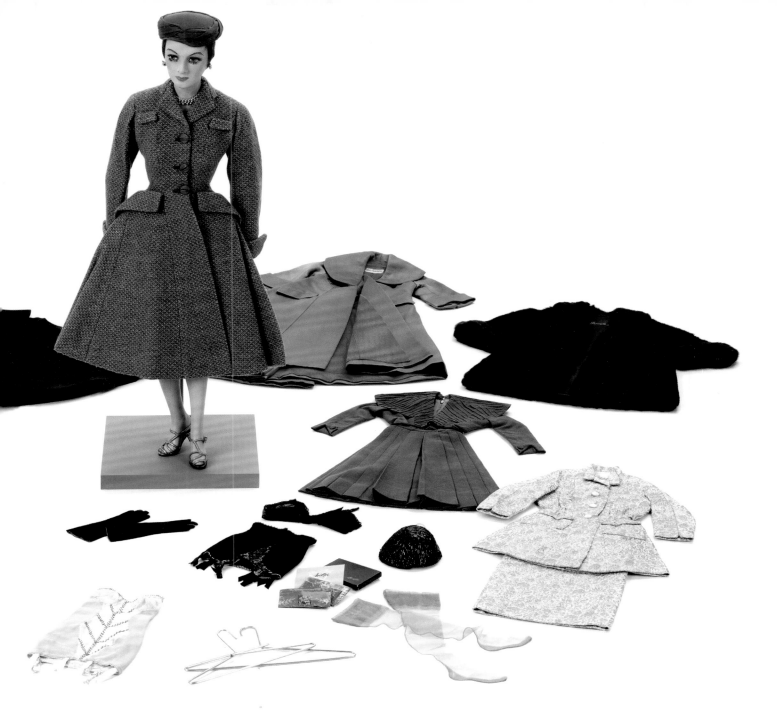

1965 Margot Fonteyn's dress

This shift dress of cream double-knit wool jersey with a navy blue cross was designed by French fashion designer Yves Saint Laurent. The dress is from his 'Mondrian' collection for Autumn/Winter 1965, which was inspired by the abstract paintings of Dutch artist Piet Mondrain. The collection was featured on the front covers of fashion magazines at the time, and continues to this day to be one of the most famous moments in 20th-century fashion. Yves Saint Laurent began his career at the House of Dior; and this dress belonged to the ballerina Dame Margot Fonteyn, who bought many of her clothes from Yves Saint Laurent after Dior's death in 1957.
Gift of Dame Margot Fonteyn

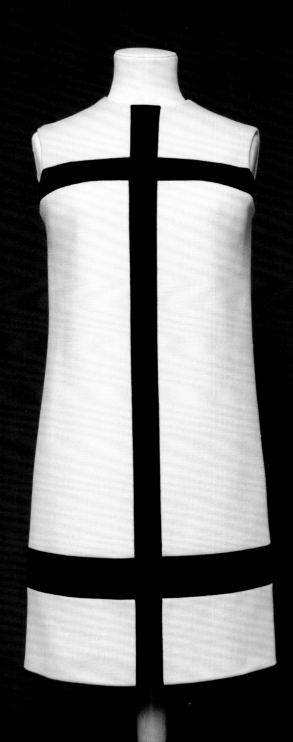

1968 Roy Strong's suit

This pin-striped suit is by Savile Row tailor Blades, and was worn by Sir Roy Strong during the years when he was director of the National Portrait Gallery in London. Blades was founded in 1962 by Rupert Lycett Green, and soon became the tailor of choice for young men in the media and the arts who were making a name for themselves, and challenging the established way of doing things. Roy Strong, for example, was only 32 when he became director of the National Portrait Gallery in 1967. The pink striped shirt and matching tie were designed by Michael Fish, who had trained as a shirt-maker at Turnbull and Asser in the early 1960s, and opened a shop in Clifford Street in London in 1966.

Gift of Sir Roy Strong

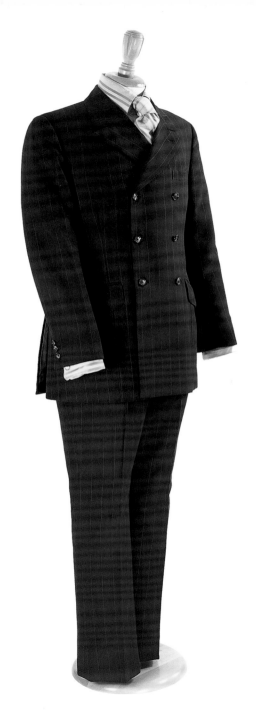

1974 Ensemble by Missoni

Both of these ensembles are by the Italian husband-and-wife design team Ottavio and Rosita Missoni, who are among the most revered of all contemporary knitwear designers. In their use of a soft and subtle colour palette, different stitches and effects in different weights and textures, the woman's skirt and jacket ensemble and the man's jumper both show Missoni's creativity and richness of imagination. Since the 1970s, their work has helped to establish knit as one of fashion's best art forms, and a beautiful fluid fashion fabric.
Gift of Missoni; selected by Joan Juliet Buck as Dress of the Year 1974

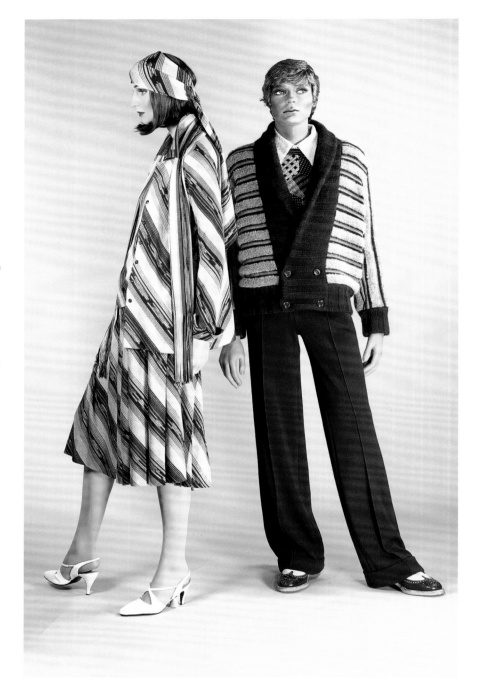

1987 Ensemble
by John Galliano

This woven cotton strapless checked dress worn over a dark coloured shirt with a matching coat was from one of British fashion designer John Galliano's earliest collections. His final year collection as a fashion student at St Martins College of Art was bought straight off the catwalk by Joan Burnstein, the owner of Brown's in South Molton Street, one of the most famous fashion stores in London. John Galliano was an immediate star of the London fashion scene, but closed his house at the end of the 1980s. After some time in the fashion doldrums he was named designer at Paris couture house Givenchy, and then in 1996 chief designer at the house of Dior. He continues to design for Christian Dior and under his own name.

Gift of John Galliano; selected by Debbi Mason as Dress of the Year 1987

21st Century
Globalisation and more and more choice

What of fashion nowadays? Is it still too early to identify trends in fashion in the new millennium, and to situate these in contemporary society?

Perhaps, more than any of the other major recent changes in the world, it is globalisation that has had a marked effect on fashion. It's true to say that at the beginning of the 21st century, in the so-called developed world, more clothes are available to more people. Low material and labour costs in China and the Far East, and in the new European countries, mean that garments can be produced more cheaply. With fashions sold now in supermarkets and high street stores, the availability and rapid turnover of cheap attractive garments is a marked trend in clothing and fashion in the new century.

Designers show more fashion collections now than at any other time in history with couture, ready-to-wear, menswear and cruisewear fashion shows taking place, in most cases, at least twice a year. Followers of fashion must keep their eye not only on collections shown in the major fashion capitals, like Paris, London, New York and Milan, but also in other cities around the world, such as Australian fashion week held in Sydney or Melbourne. It's not unusual either for a designer to design under his own name, and also for a fashion house. John Galliano, for example, designs as 'John Galliano' and as chief designer for the House of Dior. All in all, nowadays, more fashion is available from which to make a choice.

Another marked characteristic of 21st-century fashion is its casualness, some would say messiness. It does seem that, sartorially, anything goes with low-slung jeans and combat trousers and other dress-down styles having as much fashion credibility as smart dresses and perfectly coiffed hair. People might grumble and say that fashion is dead. But the perception that things are not what they used to be is in itself nothing new. In 1934 song-writer Cole Porter observed, 'In olden days a glimpse of stocking was looked on as something shocking. Now, Lord knows, anything goes!' It may be shocking, it may not be what we are used to, but fashion is alive and well precisely because it is different to what went on before.

A museum is concerned with objects from the past. Traditionally, it has been seen as a collection of artefacts from way back in history, such as great grand-mother's cream silk wedding dress and other precious pieces from the very mists of antiquity. However, museums today define the past as yesterday, and aim to collect fashion from the here and now so as to reflect that.

The collection of fashionable dress from the 21st century at the Fashion Museum is not large, but it is significant and continues to grow every day. Most of the dresses have been donated to the museum by fashion designers as part of the Dress of the Year scheme. This innovative scheme, which ensured that one ensemble from the current year was added to the museum's collection, was originated by Doris Langley Moore, the museum's founder in 1963. The Dress of the Year scheme continues along similar lines to this day, with the choices made by fashion experts forming the backbone of the museum's collection of up-to-the minute fashion.

2000 Evening dress by Versace

This long-sleeved floating blue and green bamboo-print silk chiffon dress is by Donatella Versace, who took over as design director of Versace after the murder of her brother Gianni in 2007. In the words of fashion editor Lisa Armstrong, who chose the dress for the Fashion Museum collection, it is glamorous, yet supposedly effortless; romantic, and yet brash. The dress, which is mounted on a halter-neck swimsuit was originally worn on the catwalk by model Amber Valetta in Versace's Spring/Summer 2000 show; but then it caused a sensation when it was worn by Jennifer Lopez at the Grammy Awards in Los Angeles in February 2000. Celebrity endorsement is a significant fact in early 21st-century fashion. 'A famous body in your frock can catapult a designer on to the front pages and shift untold units', wrote Lisa Armstrong in 2000. The Versace dress is a perfect example of this modern-day link between celebrity and fashion.
Gift of Versace; selected by
Lisa Armstrong as Dress of the Year 2000

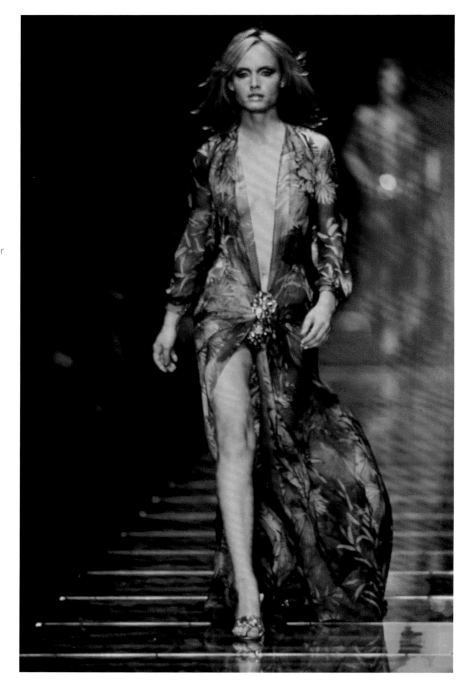

2001 Ensemble by Yves Saint Laurent Rive Gauche

This peasant blouse ensemble is by Tom Ford for Yves Saint Laurent Rive Gauche and is from his Autumn/Winter 2001 collection. Yves Saint Laurent Rive Gauche was one of the first ready-to-wear boutiques in Paris. It opened in 1966 and set the tone for the way that fashion would develop from couture to ready-to-wear over the coming decades. Tom Ford drew on his research in the Yves Saint Laurent archives for this collection, but gave it his own personal touch: 'Nobody needs to remake what Mr Saint Laurent has already done.' Instead, he wanted a look to emphasise his view that women should be soft, and yet strong at the same time. This ensemble, with its off-the-shoulder peasant-style blouse and roughly made gladiator-style boots, shows the exciting fusion in fashion at the beginning of the 21st century between 'boho chic' and the powerful modern dominatrix.

Gift of Yves Saint Laurent Rive Gauche; selected by Alexandra Shulman as Dress of the Year 2001

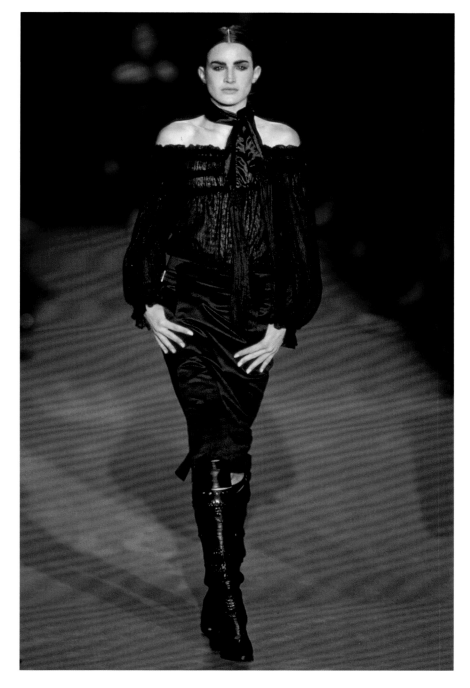

2002 Dress by Junya Wattanabe

This long black 'patchwork' dress, teamed with distressed brown cowhide brogues, is from Japanese designer Junya Watanabe's Autumn/Winter 2002 collection. Junya Watanabe joined the Japanese fashion house Comme des Garcons in 1984, and presented his debut collection ten years later under the label of *Comme des Garcons Junya Watanabe*. The sleeveless dress is made of mis-shaped and textured pieces of different types of black fabric – some knit and jersey, some woven – in a rough-hewn patchwork construction. This shows how Junya Wattanabe experiments with form and technique by using unusual and unexpected fabrics, and putting seams and other details traditionally hidden in clothing on the outside as part of the decorative scheme.

Gift of Junya Wattanabe and
Comme des Garcons; selected by
Hilary Alexander as Dress of the Year 2002

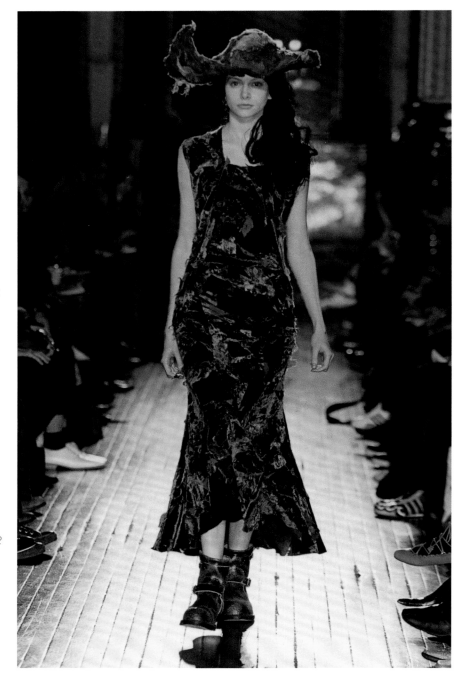

2004 Evening dress by Yves Saint Laurent Rive Gauche

This printed silk evening dress was designed by Tom Ford for his final collection as creative director of Yves Saint Laurent Rive Gauche. Fashion always works ahead of itself: this dress was from the Autumn/Winter 2004 collection, but it was shown in Paris in March 2004, and worn by actress Nicole Kidman at an award ceremony in New York in June 2004. It is made up of a bustier top and a fish-tail skirt. The Chinese-inspired pattern is a reference to Yves Saint Laurent's 1975 Chinese collection. Tom Ford also worked for the house of Gucci from 1990 to 2004, and is credited not only with re-vitalising this ailing Italian fashion label but also with putting sex back into fashion at the turn of the new century.

Gift of Yves Saint Laurent Rive Gauche; selected by Sarajane Hoare as Dress of the Year 2004

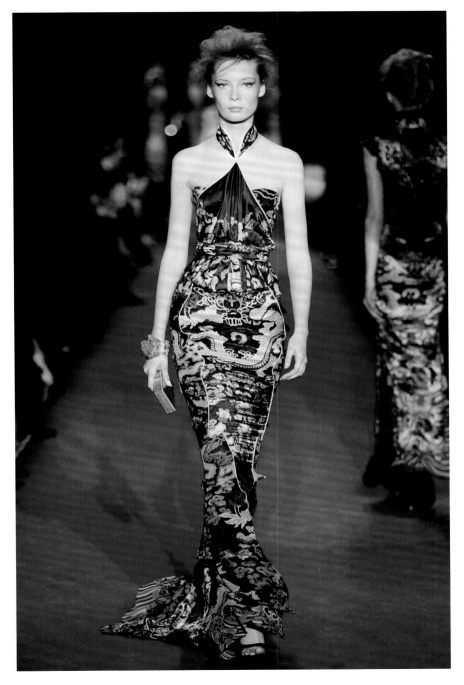

2005 Summer day dress by Lanvin

This deceptively simple, pretty summer day dress with its drop waist and tulip-shaped skirt is by Israeli designer Alber Eratz, who has revived the Paris fashion house of Lanvin. The dress is an example of how fashion has the ability to look forward to the future and to look backward to the past at the same time. The drop waist and the curving line of the skirt make reverential reference to the dresses for both children and women designed by couturier, and founder of the house of Lanvin, Jeanne Lanvin at the beginning of the 1920s. The puffed skirt, which was first seen (this time round) on the catwalk in autumn 2004, set the trend for many high street summer day dresses in both 2005 and 2006.
Gift of Lanvin; selected by Charlie Porter as Dress of the Year 2005

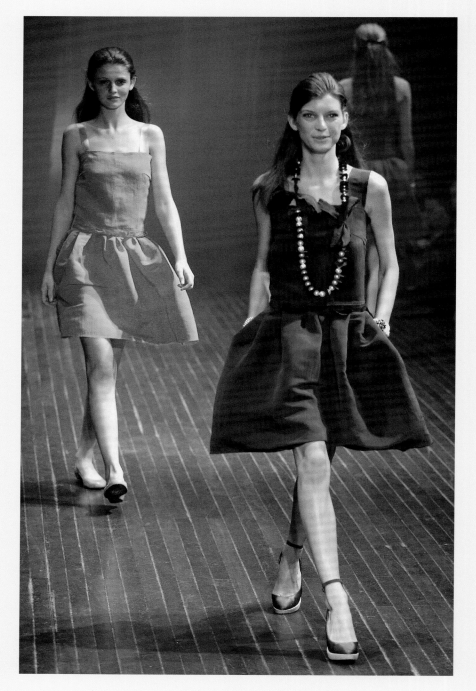

2005 Man's suit by Thom Browne

Thom Browne is a New York tailor who has dared to experiment with the traditional proportions of a man's suit. While his ⅞-length trousers, finishing well above the ankle, have attracted more attention, his tight-fitting slender jacket is also a departure from the looser styles that have been fashionable since the 1980s. Here, Thom Browne is seen wearing a light grey worsted suit similar to the one that he donated to the Fashion Museum. It's a new interpretation of a traditional style that originated way back in fashion history. It is for this reason that Thome Browne's suit, as much as any of the other pieces illustrated here, is one of the treasures in the collection of fashionable dress at the Fashion Museum in Bath.

Gift of Thom Browne; selected by Charlie Porter as Dress of the Year 2005

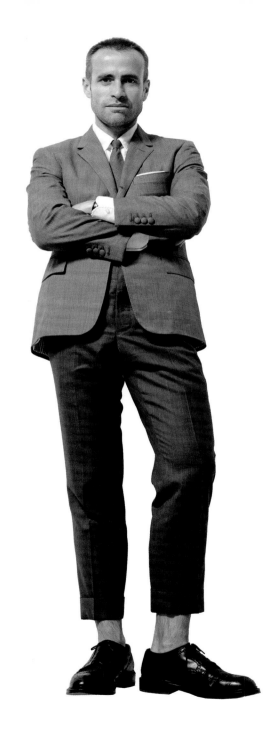

Fashion
Museum

© Scala Publishers, 2009
Text © Fashion Museum, 2009
Photography © Fashion Museum, 2009,
except for the following pages: 6 Brenda
Norrish/Estate of Jean Arnold; 7 Glove
Collections Trust; 8 Brenda Norrish/
Estate of Jean Arnold; 36 Richard Davis/
Victoria and Albert Museum; 41 Richard
Davis/Victoria and Albert Museum;
42 Richard Davis/Victoria and Albert
Museum; 48 & 45 Kikuko Usayama; 50
Versace; 51 & 53 Yves Saint Laurent
Rive Gauche; 52 Jean Francois Jose; 54
Catwalking.com

First published in 2009 by
Scala Publishers Ltd
Northburgh House
10 Northburgh St
London EC1V 0AT
Telephone: +44 (0) 20 7490 9900
www.scalapublishers.com
ISBN-13: 978 1 85759 553 6

Text: Rosemary Harden,
Fashion Museum
Photography for the Fashion Museum
by James Davies, Fotek, Julian James,
Mandy Reynolds and Nick Smith
Editor: Stephen Clews,
Fashion Museum
Project Editor: Esme West,
Scala Publishers
Design: HDR Visual Communication
Printed and bound in Singapore

10 9 8 7 6 5 4 3 2 1

British Library Cataloguing in Publication
Data. A catalogue record for this book is
available from the British Library.

Fashion Museum
Assembly Rooms
Bennett Street
Bath BA1 2QH
www.fashionmuseum.co.uk
24 hour information:
Tel. +44 (0)1225 477867

The collections in the Fashion Museum
are Designated by the Museums,
Libraries and Archive Council as being of
national importance and are managed by
Bath & North East Somerset Council.